Sustainable, Sun-Grown Cannabis

A Visual Guide to Environmentally Friendly Marijuana

Justin Cannabis

Amherst Media, Inc. ■ Buffalo, NY

Special Thanks

This book would not be possible without the warm and generous access to Humboldt's Finest Farms. Special thanks to Matt, Kristin, Trent, and Sage for their trust and patience along the way. Thanks, as well, to cannabis cultivators everywhere who strive to produce a pure and sustainable harvest for the world to enjoy.

Copyright © 2019 by Justin McIvor.
All rights reserved.
All photographs by the author unless otherwise noted.

Published by:
Amherst Media, Inc.
PO BOX 538
Buffalo, NY 14213
www.AmherstMedia.com

ISBN-13: 978-1-68203-420-0
Library of Congress Control Number: 2019932351
Printed in the United States of America
10 9 8 7 6 5 4 3 2 1

No part of this publication may be reproduced, stored, or transmitted in any form or by any means, electronic, mechanical, photocopied, recorded or otherwise, without prior written consent from the publisher.

Notice of Disclaimer: The information contained in this book is based on the author's experience and opinions. The author and publisher will not be held liable for the use or misuse of the information in this book.

The information contained in this book is presented for educational purposes only. Check with your local, state, and federal laws regarding possession, consumption, and cultivation of cannabis. If you seek to use cannabis to treat a medical condition, consult with your physician or a licensed health-care provider first.

AUTHOR A BOOK WITH AMHERST MEDIA

Are you an accomplished photographer with devoted fans? Consider authoring a book with us and share your quality images and wisdom with your fans. It's a great way to build your business and brand through a high-quality, full-color printed book sold worldwide. Our experienced team makes it easy and rewarding for each book sold—no cost to you. E-mail **submissions@amherstmedia.com** *today*.

www.facebook.com/AmherstMediaInc
www.youtube.com/AmherstMedia
www.twitter.com/AmherstMedia
www.instagram.com/amherstmediaphotobooks

Contents

About the Author .4
Foreword .5

Humboldt's Finest Farms6
Mulch .8
Hoop House .8
Symbiosis. .9
Dynamic Duo .9
A Healthy Start .11
The Till .12
Irrigation. .12
Preparations. .13
Soil-Building .13
Proper Hydration14
Under Cover .14
Plans .15
Great Appeal .15
Predators. .16
Garden Variety. .16
Spiders. .17
Permaculture. .17
Young Plants .18
Blue Dream .21
OG Glue .21
XJ13 Plants .22
The Cycle .22
The Chosen Few .23
Careful Oversight23
Health and Vigor.24
Topography. .24
Smart Pots. .24
Sunset Sherbert .27
OG Kush. .27
Scout Master .29
XJ13 .29
Unique Strains. .30

Young Starts .32
Optimal Circulation.32
Security .32
Raised Beds .32
Greenhouse Plastic.35
Added Warmth .35
Support System .35
More Support .35
Flowering Stage.36
Balance and Symmetry.36
Room to Flourish37
For the Flowers .37
Plenty of Sun. .38
A Sun-Grown Garden40
A Robust Garden.40
Win–Win .41
Best Practices. .42
Solar Panels .43
Necessary Power43
Strategic Placement44
Minimizing Noise Pollution.44
Batteries .44
Power Lines. .44
Sustainable Paradise.47
Conservation .48
Irrigation Tanks.48
Rainwater .49
Well-Timed Watering.49
Iconic Beauty. .51
Polyculture. .52
Crop Rotation .52
Year-Round Harvest53
Composting. .53
Brilliant Displays54
Taking a Page from History.54
Harvest Through Diversity55

Hillside Beauty .55	Perpetual Harvests.87
Vegetables .56	Take Cover .88
Reduce and Reuse56	Close-Up. .89
Staggered Heights57	Open-Air Garden.91
Happy Accidents57	Corn Stalks .93
Poised for Success58	Bamboo Poles .94
Terracing. .59	Reaping the Rewards96
Beneficial Insects60	Teamwork .98
Integrated Pest Management60	Great Garden Variety100
Deep Purple .61	A Bounty of Color.103
Native Ground Cover61	Super Silver Haze105
Big Leaf Ranch .62	Patience and Persistence.106
Humboldt Nation Farms62	Massive Harvest.109
Mattole River Farms63	Perfect Sun .111
Japanese-Style Greenhouse.64	A Room with a View112
Pest Patrol .67	Strength and Resiliency114
All Hands on Deck69	A Perfect Plant.115
Quality Control .70	Varied Root Systems116
A Strong Start .72	Full Bloom .118
Sky High .75	Slow and Deliberate Curing.119
A Top Strain .76	Harvest .121
Conserving Water79	Curing Room .122
Centerpiece .80	To Your Health!124
Cloaked in Sun .83	
The Spice of Life84	*Index* .126

About the Author

Growing up hiking and skateboarding in Northern California's Sonoma Valley, Justin was surrounded by award-winning vineyards and equally beautiful clandestine cannabis gardens. His love for photography and his incredible access to the cannabis scene provided a unique opportunity to carve out a career in the niche markets of commercial and editorial cannabis photography.

After receiving a Bachelor of Arts degree in Industrial Scientific Photography from Brooks Institute in Santa Barbara, California, Justin began his professional career in the biomedical field photographing DNA blots for Genetech, a global leader in cutting-edge cancer research. After a couple of years in the lab, he was eager to explore his options in professional photography, so he switched gears to fulfill a teenage

dream of creating images for the legendary Santa Cruz Skateboards. In the studio at Santa Cruz, he produced several cannabis-related graphics for skaters who embraced our favorite herb. When the local green community blossomed in the late '90s, Justin was in a prime position to create new images and market them to forward-thinking media outlets like *High Times*, the most popular and infamous cannabis magazine on the planet.

Since then, Justin's images have graced more than 50 magazine covers, dozens of books, and countless calendars and posters sold the world over. He has also been blessed to have his work appear in several mainstream media outlets including *Time, Newsweek*, and the ultimate photography and design showcase, *Communication Arts*. Justin's work has also been shown in the Oakland Museum of California, and in galleries up and down the west coast.

Through all of this, Justin has met lots of wonderful people and traveled to many beautiful gardens all over the world, creating an incredible archive of cannabis images to share.

Foreword

This visual feast of images celebrates Humboldt's Finest cannabis growers and their dedication to Mother Earth. They adhere to Mother Nature's life-giving, nurturing practices to grow world-famous cannabis. Environmentally friendly cannabis production is a way of life for these farmers, who are literally living off the land.

Sun-grown cannabis thrives in rich, organic soil on their farms in pristine Humboldt County, California. Natural sunlight generates sustainable electricity off the grid. These stewards of the land use local amendments to build sustainable organic soil that becomes more fertile with each crop. Working in harmony with nature, astute growers harness abundant subterranean water and rainwater to irrigate organic crops that are nestled in this ideal cannabis-growing climate. These farming practices yield potent, fragrant, sweet-tasting cannabis, while generating a negative carbon footprint.

World-class cannabis shares rich organic earth with carefully selected flowers, fruits, and vegetables. This polyculture technique benefits soil life, as well as the mind and soul. In short, permaculture rules at Humboldt's Finest.

Please turn the page to start your tour of Humboldt's Finest. You will see that it's good for you, and good for the planet.

—Jorge Cervantes, best-selling author and celebrated expert on cannabis

Humboldt's Finest Farms

Humboldt's Finest Farms (HFF) is an award-winning collective of environmentally focused farmers and land stewards who grow some of the best cannabis on the planet. This book aims to provide a vivid look into their magnificent gardens and provide insight into important practices critical to the future of sustainable outdoor cannabis production.

Hoop House

above. A fine example of various HFF strains of cannabis grown in an open-ended "hoop house" located in the beautiful Mattole River Valley area of Humboldt. When the temperatures rise, fans, vents, and roll-up siding help the garden stay well-ventilated and cool. During cold and wet weather, the hoop houses can be sealed up to avoid excess moisture, which can wreak havoc in the garden.

Mulch

above. In the Humboldt hills, they like to mulch the soil beds with straw to reduce evaporation and keep the moisture and nutrients in their place.

Symbiosis

right. The beautiful mountaintop locations of Humboldt Nation Farms feature dynamic polyculture techniques, combining cannabis with a variety of symbiotic flowers and vegetables for a healthier garden design.

Dynamic Duo

below. Full natural sun and bio-dynamic gardening techniques result in incredibly healthy cannabis, like this magnificent flower, high in the Humboldt hills.

A Healthy Start

It begins with the soil. Carefully nurturing the beds of their gardens, Humboldt's Finest farmers ensure a healthy and striving ecosystem with incredible results. By growing in native soils, small boutique farms enjoy the distinction of a specific *terroir*, the French word for earth or soil. The terroir takes into account the garden's soil, climate, geography, and other factors that have a distinctive effect on the taste, smell, and overall quality of cannabis flowers.

The Till

top. Preparing the soil for a new cannabis crop, one of Humboldt's Finest garden helpers tills the fertile beds. By attentively mixing in organic amendments and properly aerating the soil, the farmers can look forward to a successful harvest, year after year.

Irrigation

bottom. A farm helper systematically checks irrigation sprayers on down the line. Leaks in the system can be costly to the farm and the environment, so it's imperative to inspect often.

Preparations

above. After tilling and amending the soil, a farm helper evens out the beds with a gardening rake for a uniform surface. This technique helps water percolate evenly into the nutrient-rich soils for a thriving root structure.

Soil-Building

right. Soil-building involves recycling and amending along the way, extending the life of this precious resource and protecting the environment from needless waste.

Proper Hydration

top. Irrigation sprayers hydrate the soil beds ahead of planting to help guarantee a proper environment for the plants. Proper soil hydration is critical to a thriving crop, and Humboldt's Finest farmers are on top of their game.

Under Cover

bottom. Smother grasses and other farm-friendly ground covers can keep dust to a minimum while attracting beneficial predator insects to the garden.

Plans

above. Creating a plant-area propagation plan is an important step toward maximizing a cannabis crop's potential. Here, a coded map outlines the locations of several different cannabis strains from Humboldt's Finest Farms. Another best practices method featured here is straw mulching. This handy conservation technique can prevent up to 3/4 of the soil's moisture from evaporation during the long hot summer days.

Great Appeal

above. Flowers planted in and around cannabis gardens can attract beneficial insects, such as this bumble bee, which gathers the nectar from this English lavender plant.

Predators

top. Introducing flowers and vegetables (hopefully native!) to your cannabis area will attract beneficial predators, like this yellow jacket, who will make quick work of damaging pest insects. It's a far superior and all-natural way to protect and enhance your garden space.

Garden Variety

bottom. Cannabis gardens large and small benefit from living with many different varieties of plants. Soil enrichment, water conservation, and the attraction of beneficial predator insects are just a few of the advantages of this technique, practiced in this beautiful Humboldt hills garden.

Spiders

below. According to Humboldt's Finest farmers, spiders are a welcome guest to any of their gardens. They protect the garden by consuming thousands of plant-eating insects a day, greatly minimizing the need for insecticides, which can harm the environment and the health of the cannabis consumer.

Permaculture

below. A combination of plants working together in perfect balance with their environment: it's permaculture 101. A garden that looks this amazing from above certainly must have an equally incredible subterranean root zone.

Young Plants

Cannabis plants are available in a variety of cultivars, known in the cannabis industry as strains, each offering distinct characteristics. Most cannabis cultivars in today's market are hybrid varieties, which highlight unique fragrances and potencies from a variety of strains. Here, rows of healthy young plants await transplanting into a larger space, where they will continue to grow and flourish toward a bountiful harvest.

Blue Dream

previous page. This rare genetic variety or phenotype is from a strain known as Blue Dream, one of the most popular picks for selective cannabis growers on the west coast of California. It's a hybrid strain of both blueberry indica and sativa haze, capable of producing incredible traits seen here and prized by farmers and their most discerning cannabis consumers.

OG Glue

above. Here's another beautiful selection from Mattole River Farms. This OG Glue cannabis strain in full bloom exhibits the incredible potential of sun-grown, organic cannabis.

XJ13 Plants

left. A young, thriving batch of XJ13 plants await the selection process before transitioning into a controlled light-cycle environment for flowering. Prized selections of each cultivar will be welcomed into the flowering stage to ensure a successful harvest.

The Cycle

below. From the greenhouse to the hoop house, a farm helper continues the cycle on Humboldt's Finest Farms.

The Chosen Few

above. The chosen few move forward into bloom, while the rest can be recycled into the soil, providing nutrient-rich bio matter to be utilized in future crops. Humboldt's Finest farmers aim to reuse and recycle whenever possible to decrease waste and sustain a healthy environment for future generations.

Careful Oversight

above. The key to success is being present and mindful of the plants' needs, and an experienced and careful eye is of utmost importance to a successful crop. Here, a farm manager surveys young plants, looking for problems to address before cycling the plants into a new space to mature and flower.

Health and Vigor

top. The success of any cannabis garden is highly dependent on the health and vigor of young plants. Small, independent gardens as well as industrial-scale growers need to carefully evaluate their plants at every stage of growth to ensure success.

Topography

bottom. Working with the natural curves of the land is a prefered method of the permaculture movement. Permaculture is defined as a harmonious integration of the landscape. Here, one of Humboldt's Finest Farms takes advantage of the twisting topography for maximum exposure to the full sunlight.

Smart Pots

following page. Humboldt's Finest farmers use fabric "smart" pots for their young plants. They encourage a strong root system by providing an anchor for wandering lateral roots and a porous container material for proper drainage and increased airflow to the plant's soil. Smart pots are also great for minimizing plant shock during transplanting; you simply place the entire container into a healthy soil bed to encourage new root growth.

Sunset Sherbert

previous page. A staple of Humboldt's Finest offerings is the incredible hybrid Sunset Sherbert strain. Prized for its intoxicating smell of blackberries, Sunset Sherbert is a highly popular variety developed by Mr. Sherbinsky, a legendary Northern California breeder.

OG Kush

below. While always looking for new, exciting strains to grow, Humboldt's Finest also reserves space in their gardens for tried-and-true varieties like this OG Kush, a longtime favorite among cannabis aficionados around the world. It's especially popular on the west coast, where it has gained a strong following over the years.

Scout Master

previous page. The fine hybrid cultivar known as Scout Master is a farm favorite in Humboldt. Easy to grow throughout the Humboldt area, it is highly tolerant to a variety of weather conditions and produces magnificent harvests season after season.

XJ13

above. Another top choice of Humboldt's Finest and other west-coast cannabis aficionados is the hybrid XJ13 strain. Long and lanky in a good way, this sativa-dominant strain nicely complements the short, stocky kush strains in the garden.

Unique Strains

right. Unique strains stand out in a crowded market of so-called premium cannabis flowers. And when those flowers are grown to perfection in the Humboldt hills under the California sun, they shine even brighter.

Young Starts

top. A fresh new batch of adolescent plants wait for their turn in the sun. It's important to have an abundance of juvenile plants to safeguard against unforeseen problems and guarantee a successful outcome in the garden.

Optimal Circulation

bottom. Replenishing the raised beds with a new round of young, healthy recruits, the farmers carefully space the plants for optimum circulation and growth.

Security

following page, top. Cannabis gardens are a great healing space for humans and animals alike. A now-retired chief of canine security soaks up the rays and enjoys another beautiful day on the mountain.

Raised Beds

following page, bottom. Planting in raised beds helps to keep soil erosion at a minimum while improving moisture retention. Saving water is of utmost importance to Humboldt's Finest farmers.

Greenhouse Plastic

top. Using heavy-duty greenhouse plastic allows farmers to control the temperature and humidity of the garden. On warm days, the walls can be easily rolled up to let in cool breezes and help the plants grow stronger as they move with the wind. On cool days, the light-transmitting walls help relegate the temperature as the plants naturally work together to create a normalized greenhouse environment.

More Support

bottom. Here's another look at a successfully supported garden utilizing trellising in the Humboldt hills. These plants would surely fall under the weight of their flowers if the farmers had left them to grow unsupported. Proper planning and best practice techniques result in this gargantuan display of cannabis perfection!

Added Warmth

previous page, top.

Industrial heating is sometimes needed in cold weather. This solar-powered heater is another example of the clever methods used to help young plants adjust to new environments. Many of today's popular strains are adopted from areas close to the equator, where temperatures are mostly warm. Plant growth slows rapidly in low temperatures, but these plants will have a head start with a carefully controlled climate.

Support System

previous page, bottom.

Fast-growing cannabis plants are susceptible to towering vegetative growth before their root systems are capable of proper support. A best practice adopted by Humboldt's Finest is the use of trellis netting, which helps keep plants upright and in their place throughout the growth cycle.

Flowering Stage

top. Triggered by shorter light cycles, cannabis plants enter their flowering stage and a highly accelerated growth rate. Crowding issues are combated through careful pruning and trellising nets, as shown here.

Balance and Symmetry

bottom. Balance and symmetry are key ingredients for a successful crop. This image provides a glimpse at the results of careful preparation and upkeep of another beautiful cannabis garden in the Humboldt hills.

Room to Flourish

top. A single Sunset Sherbert top flowers through the trellising support. Providing equal space for plants to flourish is an important best practice technique, which leads to a consistently balanced canopy, a goal of Humboldt's Finest Farms.

For the Flowers

bottom. Similar to the rolling vineyards nearby, which share the same terroir (native soils), large-scale cannabis gardens require careful plant-supporting techniques to brace the heavy flowers.

Plenty of Sun

Growing cannabis in the sun provides a full spectrum of light, which unlocks the plant's full potential. This beautiful Humboldt garden reveals the advantages of full-sun exposure a few weeks before harvest.

A Sun-Grown Garden

above. This sun-grown garden perfectly blends with its natural surroundings in the Humboldt hills. Sunlight provides a naturally stronger source of energy than commercial indoor grow lights, which cannot compete with the sun's power.

A Robust Garden

left. These massive flowers in the garden are thriving from a combination of natural sunlight, healthy soil beds, and careful trellising to manage the towering cannabis tops.

Win-Win

Full-spectrum sunlight nourishes the plant throughout its growth cycle and greatly reduces power consumption.

Best Practices

Solar power is an integral part of Humboldt's Finest best-practices regiment. The sun not only provides a full spectrum of natural light to the plants; its energy is also captured to power a range of climate controls for off-the-grid garden sites.

Solar Panels

above. An array of solar panels soak up energy from the sun, redistributing power to irrigation pumps, circulation fans, and other utilities used to ensure a healthy crop in the Humboldt hills.

Necessary Power

above. In the heat of the summer, a solar panel provides power for cooling fans, which help the crops thrive throughout their growth cycle. Gentle breezes from the fans bring in fresh air, help control humidity, and provide movement to the plants, encouraging steady growth and stronger root systems.

Strategic Placement

above. Strategic placement of solar panels is the key to maximum efficiency in the outdoor garden. Here, south-facing panels soak up sunlight and power fans that keep the hoop houses below cool and breezy.

Minimizing Noise Pollution

center. An industrial-grade solar-powered generator located inside a soundproof enclosure ensures a steady supply of power, while minimizing noise pollution in the natural environment.

Batteries

bottom. An array of batteries on site store power from the solar panels located around the garden.

Power Lines

following page. Power lines from the generators are safely and securely enclosed within a Humboldt's Finest garden plot in accordance with best practices and local regulations.

Sustainable Paradise

A sustainable paradise garden in the hills above the Eel River displays carefully arranged hoop houses containing another award-winning cannabis crop from Humboldt's Finest Farms. Look closely and you'll notice solar power panels, water storage tanks, and a natural rain-fed reservoir in the background.

Conservation

top. Here's a view of altogether sustainable water and energy conservation, deep in the Humboldt hills. These systems are located throughout the farms for increased efficiency.

Irrigation Tanks

bottom. Large irrigation tanks located around the garden feed the soil with homemade beneficial bacteria teas, naturally promoting optimal nutrition throughout the plants' growth cycle.

Rainwater

top. Rainwater captured during the wet season is stored in giant tanks located strategically around Humboldt's Finest Farms. Water conservation is paramount in the area, as local streams and rivers have long been compromised from years of logging activity.

Well-Timed Watering

bottom. Life-giving nutrient-fortified water is hand-delivered to a Humboldt hills garden in the early morning or late afternoon to improve soil absorption and reduce runoff.

Iconic Beauty

Iconic scenes of beauty abound in the Humboldt hills, where one can glimpse the biodiversity and reflective resource management perfectly balanced with the natural environment.

Polyculture
above. Polyculture is the practice of growing everything together as nature intended. Fruits, vegetables, herbs, and flowers bloom in perfect harmony. Humboldt's Finest utilizes this method to expand their harvests, while energizing the fertile soil and those lucky enough to enjoy the edible bounty.

Crop Rotation
left. Growing different species of crops together can help with soil stability and greatly reduce the need for added fertilizers. By rotating different crops through the garden, the farmer can guarantee soil rejuvenation and vitality for generations.

Year-Round Harvest

above. One of the many advantages of employing polyculture is the abundant diversity of plants that can be harvested year-round. Delicious and nutritious, flowers and vegetables grow alongside cannabis in a symbiotic garden deep in the Humboldt hills.

Composting

right. Composting naturally enriches future garden soils organically, as food scraps and other debris create an abundance of nutrients for the next round of crops. Zero waste is an objective passion for Humboldt's Finest farmers, and an integral part of their best-practices regiment.

Brilliant Displays

below. A healthy ecosystem displaying brilliant colors is a welcome habitat for highly beneficial insects like bees, collectively responsible for over three-quarters of the fruit, nut, grain, and vegetable crops in the U.S. annually.

Taking a Page from History

below. Long before Humboldt's cannabis farmers, indigenous cultures grew many different local crops together and enjoyed the same benefits of health and sustainability. Highly nutritious foods, like kale, grow perfectly alongside cannabis, sharing water, air, and nutrients, in harmony with nature.

Harvest through Diversity

above. Polyculture includes growing various strains of cannabis together, further guaranteeing a successful harvest through diversity. Certain strains of cannabis are susceptible to problems, such as insect damage and mold, common to monoculture gardens, which are single-crop plantations. Polyculture offers a great aid to these issues by encouraging natural growth borders around the plants, creating natural routes for predator insects, who help keep the garden free of pests.

Hillside Beauty

above. Growing with the land is another primary goal for Humboldt's Finest, as displayed in this hillside polyculture beauty, sparkling in the afternoon sun.

Vegetables

above. Seasonal edible vegetables are a welcome sight to farm visitors year round in the Humboldt hills. While cannabis plants wait for an early spring planting, many other species of plants take root in their place, providing the essential building blocks of nutrients for the next cycle of growth.

Reduce and Reuse

left. Reduce and reuse are methods used to great effect in Humboldt's Finest Farms. Plants and soils are recycled throughout the season in preparation for future gardens. Here, a robust volunteer cannabis plant watches over the natural process of regeneration, as recycled root balls are revitalized into fertile soils.

Staggered Heights

above. A polyculture garden strategically grown alongside the natural environment displays a variety of plant sizes, shapes, and colors. Rather than conform to the monoculture method of rows and rectangles of crops with even heights, Humboldt's Finest Farms offers a view more in tune with nature through diversity.

Happy Accidents

above. Sometimes happy accidents present themselves as a result of the recycling processes used in fundamental permaculture methods. Here, a cannabis plant naturally regenerates and provides a breath of fresh air to an otherwise low key (though very important) area of the farm.

Poised for Success

Even in small raised beds, cannabis plants can flourish alongside traditional garden varietals. Endless variations offer amazing benefits to gardens in all shapes and sizes, and the farmers of the Humboldt hills understand that diversity is the key to a successful harvest.

Terracing

Often, uneven terrain in the natural environment presents problems with erosion, which can be detrimental to a plant's root system and stability. Terracing plants can be highly effective when working within the natural landscape.

Beneficial Insects

below. A punch of purple lavender contrasts the cannabis in this polyculture garden, attracting beneficial insects, like the Cabbage White butterfly, to the farm. Butterflies enjoy a fantastic view into the ultraviolet spectrum of light, which many flowering plants use to attract pollinators who thrive in the gardens of the Mattole River Farm.

Integrated Pest Management

below. A lady beetle searches for a meal of harmful insects on the tip of a cannabis leaf. Integrated pest management, or IPM, is a creative way of eliminating unwanted pests without the use of toxic pesticides. IPM encourages the integration of predatory insects, like lady beetles and praying mantises, into the gardens to control pest damage and enhance the ecosystem.

Deep Purple

above. The deep purple of this Sunrise Sherbert cannabis strain contrasts beautifully with the many different plant varieties within Mattole River Farms, another one of Humboldt's Finest. The farm's close proximity to the river provides a naturally occurring air flow from the cool waters, which helps during the warm summer months.

Native Ground Cover

above. Native ground cover is encouraged to flourish around the garden, helping to keep the soil in its place while reducing evaporation. Natural ground covers also attract beneficial insects like lady beetles and other welcome visitors to the garden.

Big Leaf Ranch

above. High above the mighty Eel River lies Big Leaf Ranch, an environmentally conscious farm helping to set the standards for sustainable land stewardship while producing award-winning cannabis flowers for the world to enjoy.

Humboldt Nation Farms

above. Humboldt Nation Farms is another forward-thinking cannabis utopia that stays busy developing new methods to maximize sustainability and efficiency. Sun-powered and fully flowered, this garden is a hive of activity year round. The farmers of Humboldt Nation work tirelessly to produce high-quality, naturally grown cannabis for today's discerning and health-conscious consumers.

Mattole River Farms

Mattole River Farms shows a varied and vibrant display of edible plants and flowers perfectly integrated into lush fields of cannabis. Situated alongside the gently gliding river, the gardens enjoy cooling winds and a favorable year-round climate for successful harvests year after year.

Japanese-Style Greenhouse

At Big Leaf Ranch, young plants begin their journey in this beautifully designed Japanese-style greenhouse.

Pest Patrol

Pest and rodent control under strict supervision by a feline helper on Big Leaf Ranch. Enlightened farmers have long embraced the company of domesticated cats, who not only serve as inexpensive pest eradication, but provide a soothing and entertaining presence on the ranch.

All Hands on Deck

It's all hands on deck at Big Leaf Ranch, as farm helpers carefully transplant young cannabis plants into the hoop house where they will flower until harvest. This continual process requires dedication and efficiency to remain sustainable on this little patch of paradise in the Humboldt hills.

Quality Control

Quality control is of utmost importance for Humboldt's Finest Farms. Here, an eagle-eyed farmer double-checks irrigation lines powered by solar energy—best practices at work!

A Strong Start

Young cannabis plants climatize and spread their roots in the rich soil beds of Big Leaf Ranch. The health and vitality of young starts is critical to a successful harvest in the fertile Humboldt hills.

Sky High

A towering cola bud rises from the organic soil beds and into full view at Big Leaf Ranch. Hoop houses provide ideal conditions for cannabis plants in all stages of growth, from starts to strong finishers.

A Top Strain

Sunset Sherbert is a favorite cannabis strain of Humboldt's Finest Farms. Its velvety purple colors and berry-sweet scents permeate the sunlit garden with intoxicating sights and smells.

Conserving Water

Rainwater captured and stored during the wet months provides sustainability for Big Leaf Ranch and lessens the stress put on fragile local water systems.

Centerpiece

Renew, reuse, repurpose: a few permaculture practices illustrated here by an old farm truck regenerated into a sentinel garden centerpiece at Big Leaf Ranch in the Humboldt hills.

Cloaked in Sun

Glorious natural sunlight cascades through the polyculture garden of Mattole River Farms, where corn, sunflowers, and other complementary plants blend perfectly in the cannabis fields.

The Spice of Life

Humboldt's Finest farmers know variety is the spice of life. The diversity and vitality of this vegetable patch at Mattole River Farms is proof that best practices pay high dividends.

Perpetual Harvests

By influencing the light cycles and optimizing the climate through the use of hoop houses, Humboldt's farmers enjoy perpetual harvests throughout the grow season.

Take Cover

Even illumination promotes balanced growth and vitality in this sun-fed greenhouse on Mattole River Farms. Extended hot spells during the summer can be too intense for some plant varieties, which are better suited to the climatized environment of the greenhouse.

Close-Up
A closer look illuminates how full-spectrum natural sunlight invigorates this Sunset Sherbert cannabis strain close to harvest time.

Open-Air Garden

A secluded view into the open-air garden of Mattole River Farms, where the sun shines bright, the gentle winds blow, and the land is exceptionally fertile.

Corn Stalks

Stalks of corn create a natural windbreak during gusty days and nights on the farm. After a delicious and nutritious harvest, the stalks are recycled into the earth to rejuvenate the soil for future crops on Humboldt's Finest Farms.

Bamboo Poles

Giant cola buds are so heavy and abundant in Mattole River Farms that they need support from bamboo poles to stay upright. It's a problem many cannabis farmers would be happy to have.

Reaping the Rewards

A beautiful vignette of flowers and cornstalks frame a magnificent display of best practices in the garden at Mattole River Farms in Humboldt. When plants grow together in perfect harmony, the whole farm can reap the rewards of a thoughtfully designed polyculture habitat.

Teamwork

Late-afternoon sunlight filters through the gardens near the shores of the Mattole River. Cool breezes provide fresh, clean air and ideal temperatures to the garden, while offering a refreshing sanctuary for hard-working farm tenders near the mighty Mattole.

Great Garden Variety

An elevated view of Humboldt Nation Farms reveals a dynamic display of organic grape vines, fruit trees, and cannabis growing together in perfect harmony. The more you grow, the more you know, and these farmers are continually educating themselves on vitality and sustainability in the Humboldt hills.

A Bounty of Color

Permaculture practices reveal a bounty of color and plant diversity, guaranteeing a healthy harvest at Humboldt Nation Farms. Variety is the spice of life on the farm, and these experts in diversity are reaping the benefits throughout their beautiful gardens.

Super Silver Haze

Another favorite cannabis strain, Super Silver Haze dazzles with fuchsia-colored stigmas and a citrus-sweet aroma, reflecting the unique terroir of Humboldt Nation Farms.

Patience and Persistence

A gradual harvest is essential to maximizing a garden's bounty. At Humboldt Nation Farms, patience and persistence is the key to a happy and healthy crop.

Massive Harvest

A massive harvest awaits at Humboldt Nation Farms, a direct result of thoughtful planning and sustainable practices on the farm. Avoiding the uses of toxic fertilizers and pesticides, these farmers supply a healthy year-round crop of award-winning cannabis for the world to enjoy.

Perfect Sun

Sun-grown cannabis reaches for the light in this dreamy scene at Humboldt Nation Farms. When it comes to unlocking the full potential of all plants, nothing outshines the sun!

A Room with a View

A grow room with a view. The climate—including temperature, humidity, and light intensity—is easily controlled within this greenhouse environment in the Humboldt hills.

Strength and Resiliency

Solar panels help keep power flowing to the garden fans when the air is still, promoting strength and resiliency to young plants in the Humboldt hills.

A Perfect Plant

Pure sunlight, optimal nutrition, and careful observation unlocks this Strawberry Sherbert cannabis strain's full potential, just as nature intended.

Varied Root Systems

Fertile beds host a bounty of cannabis, corn, lavender, and sunflowers grown under the Humboldt sun. These varied root systems work together in a symbiotic relationship, sharing nutrients while providing protection from pests and disease.

Full Bloom

In full bloom and close to harvest at Mattole River Farms. Humboldt's Finest farmers closely monitor plant maturity to maximize the potential of their cannabis crop.

Slow and Deliberate Curing

above. Perfectly ripe cannabis cola buds hang in a dark, climate-controlled environment. Slow and deliberate curing is an important best practice that has a huge influence of the quality of the final product for Humboldt's Finest Farms.

Harvest

Harvest time at Humboldt Nation Farms occurs throughout the extended grow season, afforded by light-cycle adjustment techniques practiced in the background hoop houses.

Curing Room

Cannabis plants are hung to dry in a curing room on the Humboldt Nation Farm. A cool, humidity-controlled environment draws out the process. While the average cannabis processor might employ practices that allow them to rush their product to market, Humboldt's Finest farmers know drying and curing take time to achieve the best results.

To Your Health!

right. A spectacular harvest spread invites the viewer to consider the advantages of sustainable, organic farming for our health and the well-being of our land and resources. Commercial-scale, profit-driven factory cannabis pales in comparison to the holistic beauty, vitality, and sustainability offered by small-batch artisans like Humboldt's Finest Farms.

IMAGE GALLERY • 125

Index

B
Bamboo poles, 94
Batteries, 44
Big Leaf Ranch, 62, 64, 67, 69, 72, 75, 79, 80
Blue Dream, 21

C
Cats, 67
Cervantes, Jorge, 5
Climate, 11, 35, 63, 87, 88, 112, 119
Cola buds, 75, 94
Composting, 53
Conservation, 15, 32, 48, 56, 79
Crop rotation, 52
Crowding, 36
Cultivars, 18, 29
Curing, 119, 122

D
Disease, 116
Drying, 119, 122

E
Eel River, 47, 62
Erosion, 32, 59

F
Fans, 8, 43
Flowers, 9, 11, 16, 30, 36, 63, 83, 96, 116

G
Generators, 44
Geography, 11
Greenhouse, 22, 64
Greenhouse plastic, 35
Ground cover, 14, 61
Grow rooms, 112

H
Harvests, 53, 87, 89, 103, 106, 109, 118, 121, 124
Heating, 35
Hoop houses, 8, 22, 69, 75, 87, 121
Humboldt's Finest Farms, 6, 22, 76, 119, 124
Humboldt Nation Farms, 62, 100, 105, 109, 121
Humidity, 35, 43, 112, 122
Hybrids, 18, 27

I
Indica, 21
Insecticides, 17
Insects, 15, 16, 17, 54, 55, 60
Irrigation, 12, 14, 48, 70

K
Kush, 27, 29

L
Light, commercial, 40
Light, natural, 22, 24, 36, 38, 83, 87, 88, 89, 98, 112

M
Mattole River Farms, 21, 60, 63, 84, 88, 91, 94, 96, 118
Mattole River Valley, 8
Moisture, 8, 32
Monoculture gardening, 57
Mulch, 8, 15

N
Noise pollution, 44

O
OG Glue, 21
OG Kush, 27
Open-air gardens, 91

P
Permaculture gardening, 17, 24, 80, 103
Pesticides, 109
Plans, 15
Pollination, 60
Polyculture gardening, 9, 52, 55, 83, 96
Power lines, 44
Predators, 14, 16

R
Rain, 47, 49, 79
Raised beds, 32
Recycling, 13, 23, 56, 57, 92
Roll-up siding, 8
Root systems, 13, 17, 24, 35, 43

Runoff, 49

S

Sativa, 21, 29
Scout Master, 29
Smart pots, 24
Soil, 11, 12, 15, 16, 23, 24
Soil, amending, 12, 13, 16, 23, 52, 56, 92, 109
Solar panels, 43, 44, 114
Solar power, 42, 43, 70
Spiders, 17
Stigmas, 105
Strains, 18, 29, 30, 35
Straw, 8, 15
Strawberry Sherbert, 115
Sunset Sherbert, 27, 37, 61, 76, 89
Super Silver Haze, 105

T

Temperature, 35, 88, 112
Terracing, 59
Terroir, 11, 37
Tilling, 12, 13
Topography, 24
Transplanting, 24
Trellis netting, 35, 40

V

Vegetables, 9, 16, 56, 83, 84, 92, 96, 116
Vents, 8

W

Water, 79
Water storage tanks, 49
Weather, 8, 29

X

XJ13., 22, 29

Y

Young plants, 18, 32, 72

AmherstMedia.com

- New books every month
- Books on all photography subjects and specialties
- Learn from leading experts in every field
- Buy with Amazon (amazon.com), Barnes & Noble (barnesandnoble.com), and Indiebound (indiebound.com)
- Follow us on social media at: facebook.com/AmherstMediaInc, twitter.com/AmherstMedia, or www.instagram.com/amherstmediaphotobooks

Beauty of Cannabis
200 STRAINS OF MARIJUANA—A VISUAL GUIDE
Acclaimed photographer Spurs Broken shares macro photographs of cannabis and details the benefits of 200 unique strains. $24.95 list, 7x10, 128p, 200 color images, index, order no. 2200.

The Art of Cannabis
A VISUAL TOUR
Chris LaPrise presents imaginative, artistic interpretations of cannabis that will alter your mind and mood. $24.95 list, 7x10, 128p, 150 color images, index, order no. 2206.

Teardrop Traveler
Photographer Mandy Lea left her job for life on the road—and along the way, captured both life lessons and incredible images of America. $24.95 list, 7x10, 128p, 200 color images, index, order no. 2187.

Classic Rock
PHOTOGRAPHS FROM YESTERDAY & TODAY
Mark Plotnick and Jim Summaria present photos and text about rock and roll's legendary musicians. $24.95 list, 7x10, 128p, 230 color images, index, order no. 2205.

Vietnam Today
A VISUAL TOUR OF ITS PEOPLES & LANDSCAPES
Vietnam vet and acclaimed travel photographer John Powers explores the rural and urban sides of Vietnam today. $29.95 list, 7x10, 128p, 180 color images, index, order no. 2207.

New York Cityscapes
SEVEN TOP PHOTOGRAPHERS EXPLORE THE CLASSIC LANDMARKS & HIDDEN SPACES
Native New Yorkers explore the city's architecture and neighborhoods. $24.95 list, 7x10, 128p, 200 color images, index, order no. 2201.

Iceland
A VISUAL TOUR
Nikon Legend Behind the Lens Tony Sweet shares breathtaking images of the landscapes that make Iceland unique. $24.95 list, 7x10, 128p, 185 color images, index, order no. 2202.

Corvettes IMAGES & STORIES ABOUT AMERICA'S GREATEST SPORTS CAR
Harvey Goldstein talks with owners from around the country about their love affair with these iconic cars. $24.95 list, 7x10, 128p, 300 color images, index, order no. 2212.

National Parks
Take a visual tour through all 59 of America's National Parks, exploring the incredible histories, habitats, and creatures these lands preserve. $24.95 list, 7x10, 128p, 375 color images, index, order no. 2193.

The Moon
NASA IMAGES FROM SPACE
Take a trip to our nearest neighbor in the night sky and explore the alluring beauty and scientific wonder of the moon. $34.95 list, 7x10, 128p, 200 color images, index, order no. 2194.